African Nomad Designs
Diane Victoria Horn

Stemmer House
PUBLISHERS, INC.

Introduction

AFRICA IS THE SECOND LARGEST continent in the world, with an area that encompasses 30,334,562 square kilometers (11,712,252 square miles) of high, monotonous plateaus, dropping dramatically to narrow coastal plains. Two-thirds of the continent lies within the tropics, and it contains the largest desert in the world. The Sahara covers approximately 9,065,000 square kilometers (3,500,000 square miles) of North Africa. It extends from the Atlantic Ocean in the west to the Red Sea in the east, and merges with the Sahel to the south.

Africa is a land of contrasts, inhabited by an estimated 200,000,000 people, approximately ten per cent of the total population of the world, and of numerous ethnic and cultural backgrounds. Each group possesses its own history and its own unique artistic heritage, with a variety of creative approaches to design. This book will examine the designs created by the group of African people collectively known as bedouins. The word bedouin is derived from the Arabic "badawin," meaning "desert dweller." In Western culture, a bedouin is more commonly referred to as a nomad.

African nomads travel in caravans across the Sahara, from one oasis to another, in search of pasture and water for their herds of camels, goats, sheep or cows. The Sahara covers a territory larger than that of the continental United States, but is occupied only by approximately 300,000 nomads who periodically settle in the oases that are sparsely scattered across the desert. Camels are used by the nomads as a means of transportation, making regular treks between oases and the coastal cities. The vast area of rocky barren plains, plateaus and mountain ridges would be uninhabitable were it not for the lush green islands in a sea of sand.

The desert dwellers consist of people whose origins are derived from three vast regions that stretch across the Sahara: **The Maghreb** in the north, **The Savannah** in the south and **The Horn** of Africa in the east.

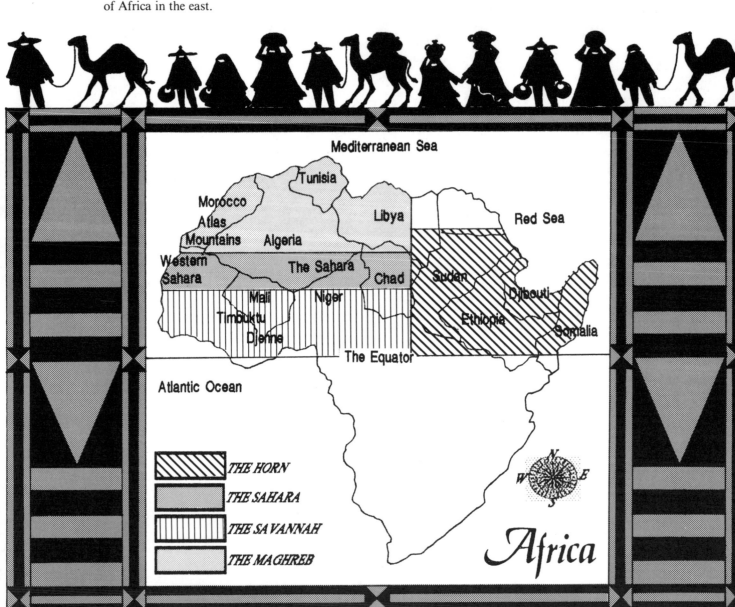

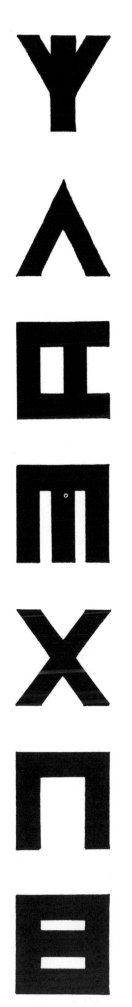

The largest groups of nomads include the Berbers and the Moors of mixed African, Berber and Arab descent who dwell on the northern fringes of the Sahara. The Fulani, of mixed Hamitic and African origins, occupy the northern Savannah of Chad and Sudan, which links North and West Africa. The Horn of Africa, in the northeastern Nubian Desert, is the home of the Rashaida nomads who crossed the Red Sea from Saudi Arabia some 150 years ago. Beja people are the original nomadic inhabitants of eastern Sudan and are probably of Egyptian ancestry. "Beja" applies to a number of subdivided groups, of whom the best known are the Haddendawa and the Beni Amer. The Beni Amer are camel breeders in the Nubian Desert, while the Haddendawa graze their long-horned cattle in the temperate climate of the Red Sea hills. The Abyssinian Christians have maintained their isolated mountain stronghold for nearly 2,000 years, while the Muslim Oromo (formerly Galla), Hareri and Somali find refuge near the coast of the Nubian desert.

All of the nomads are Muslims, with the exception of the Abyssinians, who have been Christians since the religion was established in Ethiopia by Egyptian Copts during the fourth century. Two-thirds of the total population of Africa have been followers of the Islamic faith since it was introduced by the Arabs in its early beginnings during the seventh century. In fact, Bilal, the muezzin of the Prophet Muhammad, was himself an "Ethiope," the Greek word for burnt face. The close relationship between North Africa and the Middle East is evident. For example, the word Maghreb is the Arabic name for the region of North Africa translated as "Western Arabia," and the ecological area that includes Africa south of the Sahara and most of Saudi Arabia is called the Ethiopian region.

It is safe to say that the religious doctrines of Islam are a very compelling factor in the creation of the designs produced by the African nomadic peoples. The designs common to all the arts of Islam are abstract and the motifs used can be placed into three basic categories: calligraphic, geometric and arabesques. Another equally influential element shared by the nomads is the ability to create designs that maintain their own traditional African styles within the doctrines of religious beliefs. It is these traditional differences coupled with unique individual approaches that distinguish the designs of one group of bedouins from another.

Many nomads find it too impractical, cumbersome and time-consuming to produce utilitarian or decorative items used in their everyday lives. The primary mainstay, wealth and source of prestige lies in the care and ownership of the nomad's herds. Some even feel it unworthy of breeders to manufacture anything other than materials used for herding. Therefore some of their belongings are made by craftsmen living in small market towns bordering the Sahara, although bedouins of the Maghreb weave their own textiles, and the weaving of small textiles actually has nomadic origins. In any event, African nomads have specific artistic ideas to ensure group and individual identity within the nomadic traditions. For example, some of the Berbers of the Maghreb have chosen a system of symbols referred to as "wasm," Arabic word for "mark," which Moroccan textile artists incorporate into the designs on rugs, tent bands, articles of clothing and camel bags made especially for them. Even accessories purchased at the market are customized in this way. Bedouin women sometimes embellish clothing with elaborate embroidered motifs, or paint complex tattoos of henna on their faces, hands and feet.

Many nomad women carve elaborate designs, totally of their own creation, on calabash and other gourds. The designs are incised with a variety of intricate patterns, and enhanced with decorative items such as mirrors, coins, cowrie shells and glass beads. These designs are not only remarkably beautiful but also indicate a woman's prosperity and her family lineage; often she presents the decorative calabashes to her daughters as dowries passed from one generation to the next.

Because each group exhibits its own ideas according to religion, heritage, status and unique standards of beauty, the designs in this book are divided into separate sections according to regions and individual groups. We will begin with the designs of the nomadic people in the northeastern Nubian desert of the Horn, travel west through the Sahara and the Savannah, and end in the northwestern region of the Maghreb. We will examine the intriguing iconography, explain the use of ancient symbols and discuss the types and sources of materials used to produce the designs created by the extraordinary African nomads.

Illustrations

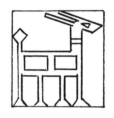

The Horn

Geographically, this is a region of immense contrasts, consisting of Sudan, eastern Ethiopia, Somalia and Djibouti. Each country shares a way of life as nomadic herders struggling to survive in the harsh and challenging environment.

Sudan and Ethiopia present great contrasts between themselves and the Horn, and serve as a bridge between northern Islamic Arab Africa and traditional Africa. In the highlands of Ethiopia their ancient church links them with Egypt.

Most borders in Africa are arbitrary and nowhere more so than in the Horn, where nomadic groups take with them customs, languages and designs that are quite different from those of the bordering countries. Although there are hundreds of district groups in Ethiopia, the largest are the Muslim Oromo warriors (formerly Galla), the Somalis and the Hareri, along with the reclusive Ethiopian Orthodox Christians, Amahara and Tigre.

Djibouti borders Ethiopia and Somalia and is strategically situated at the southern entrance to the Red Sea. Extensive migration of nomads, who may comprise up to half the population, seasonally swells or diminishes population totals. There are two ethnically distinct groups: the Somalis and the Afars (Danakil).

Sudan is lightly populated with at least fifty-six separate ethnic groups, subdivided into 597 subgroups speaking 115 languages. The rural populace consists mostly of nomadic pastoralists who occupy wide areas. Most northern and eastern nomads speak Arabic and accept an Arabic cultural heritage. Among these are the Rashaida who travel through the Nubian desert with their herds of camels. The Beja, also camel breeders, take advantage of the grazing in southeastern Sudan and across the Ethiopian border.

Comprising a triangular wedge, giving it the appearance of the lyre-shaped horn of an African cow, Somalia fronts the Indian Ocean and the Gulf of Aden bordering Djibouti and Ethiopia. Here in the largely unproductive land is the nomadic population of the Somalian cattle breeders.

Broadly speaking, the designs of the Horn reflect the lifestyles of two distinct groups, the Orthodox Christians of Ethiopia and those of the Islamic faith. The Abyssinians follow a very severe lifestyle and the designs reflect the simplicity and austerity of these nomadic people of the highlands. The remaining nomads are Muslims who venture the coastal plains and are strongly attracted to a way of life characteristic of the Middle East. For instance, the Rashaida, a proud group of orthodox Muslims, believe that women must always be veiled. Because of this belief, the burga, a heavy black cloth veil, laden with silver and gold jewelry, coins and elaborate silk embroidery, is worn as a gesture of modesty. The burga, a variation of the yashmak, is an obvious link with Saudi Arabia. Jewelry is a sign of status and a form of security for nomadic women of the Horn, and if a woman chooses to sell her lifetime collection at market, it can bring her a huge profit. The Islamic Beja, Oromo, Hareri and Somali women, by contrast, wear brightly printed clothing and headscarves from India, and do not conceal their faces behind veils. They prefer to adorn themselves with bright gold, silver and amber jewelry. The designs used by the Muslims of the Horn are so varied and strongly influenced by foreign styles that is is very difficult to know their exact origins. The illustrations that follow show a sampling of designs that are traditional to just a few nomadic groups of the Horn.

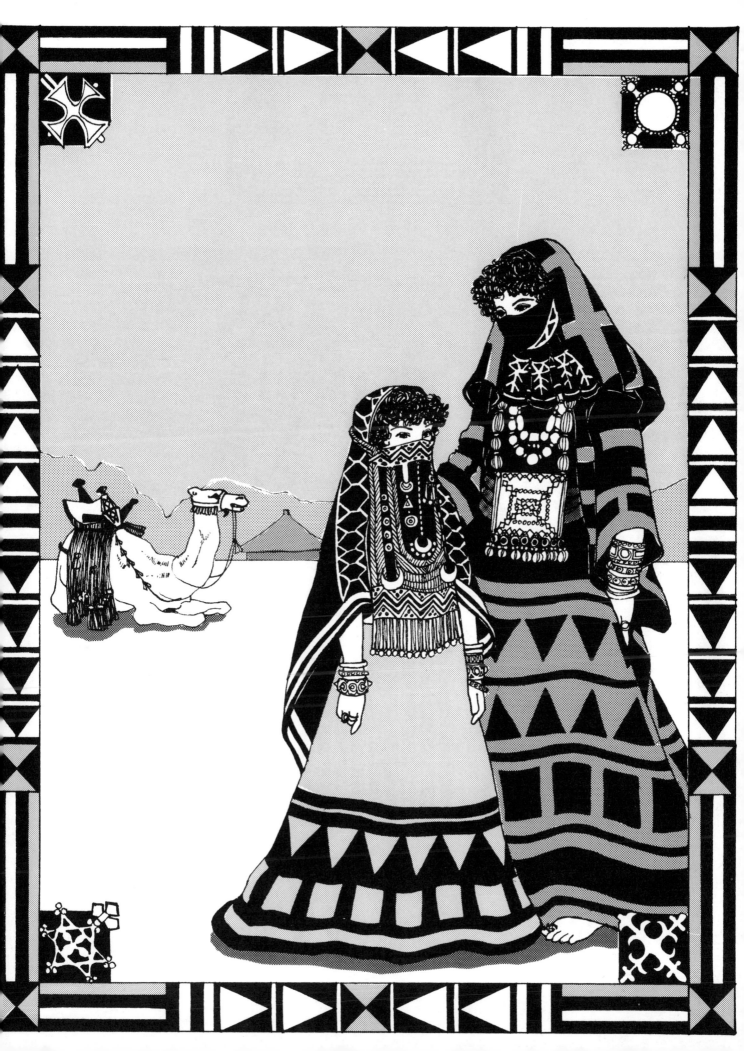

Bakan Gizo or Rainbow Dragon associated with rainfall, which brings good fortune in the desert region.

RIGAN GIWA, Robe of the Elephant

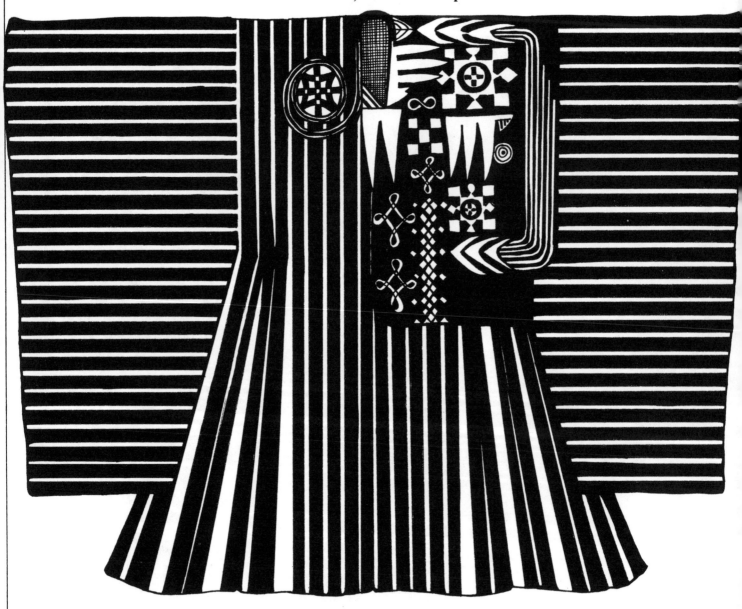

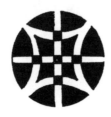

Tambari
or King's Drum

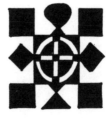

Eight-point star.
Talisman against
the evil eye.

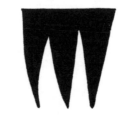

Aska: Eight Knives.
Arabic-derived Huasa term
for soldier.

House of Five or 3x3 Square:
Refers to number five (khamsa),
a charm against the evil eye.
3x3 Square represents perpetual motion.

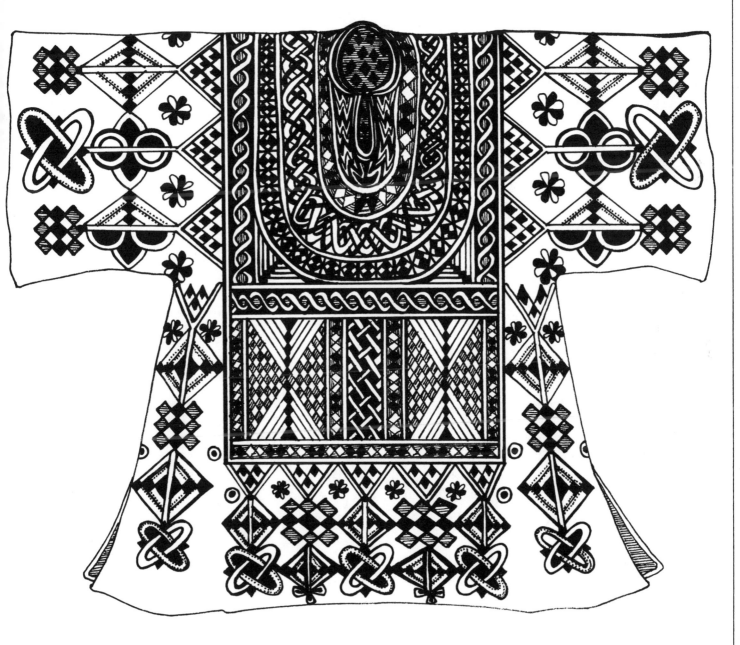

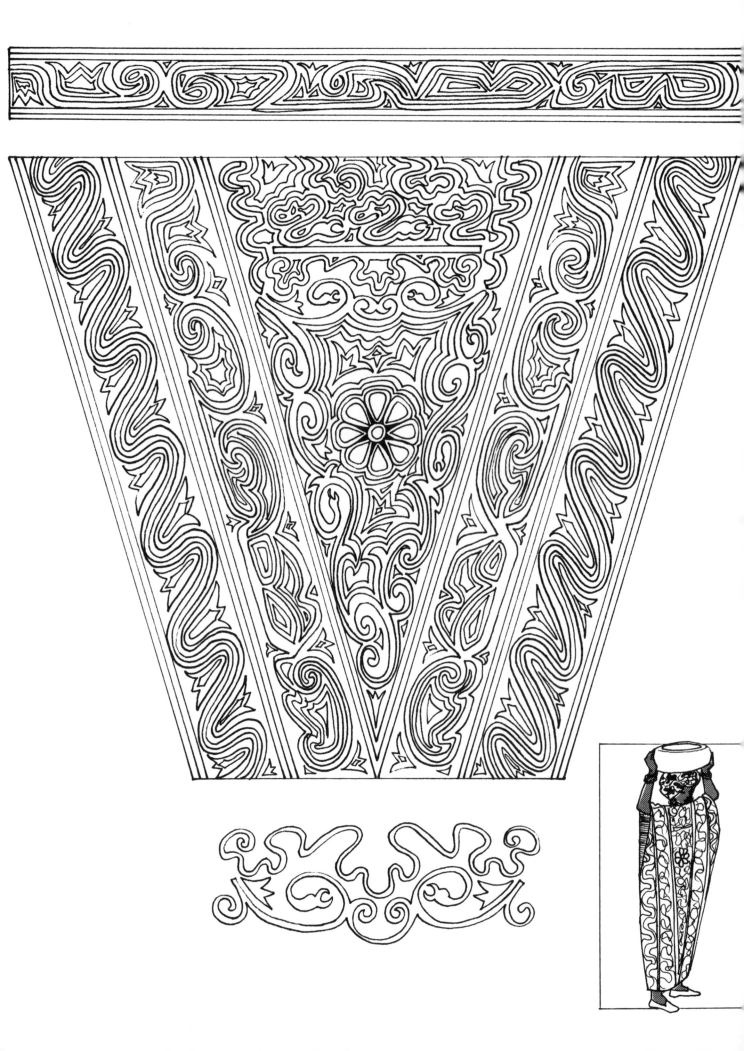

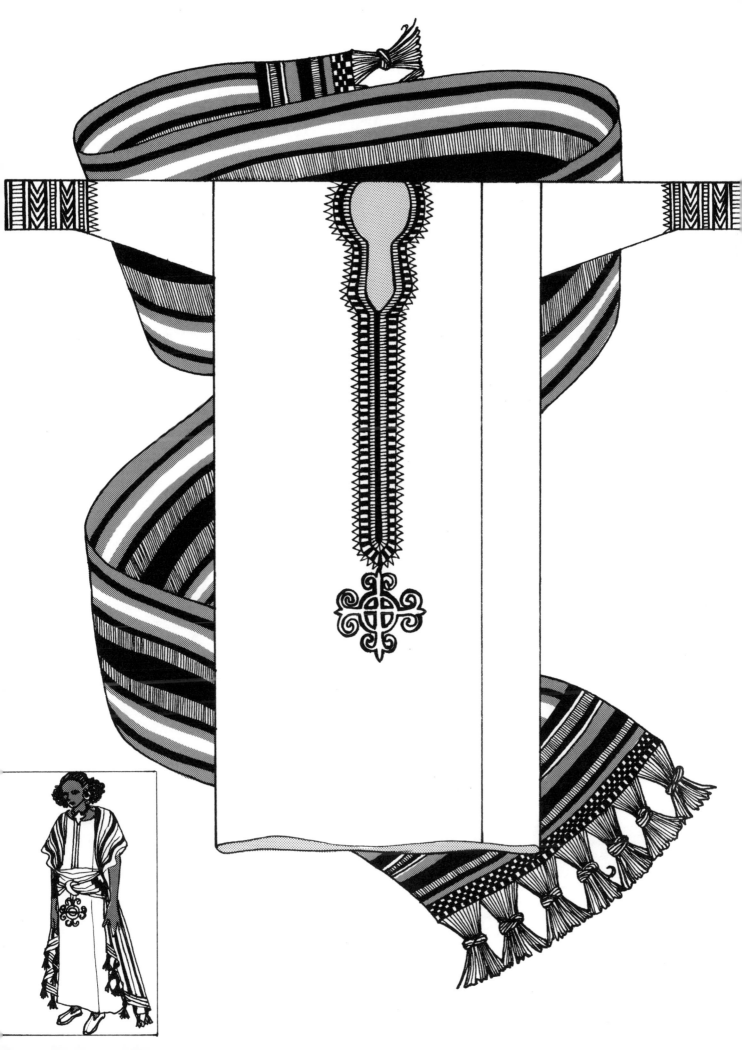

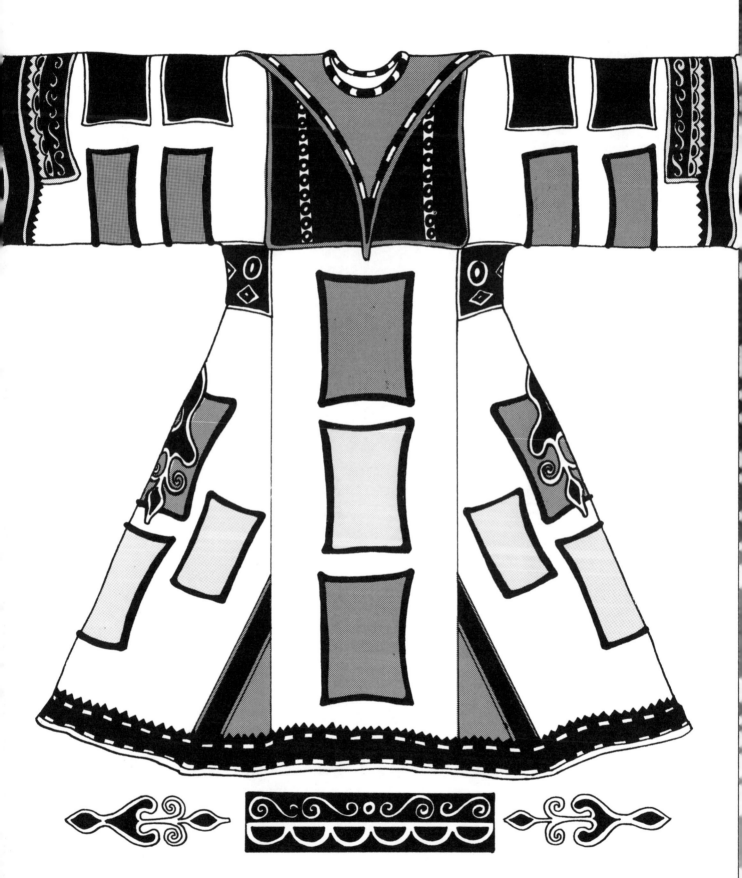

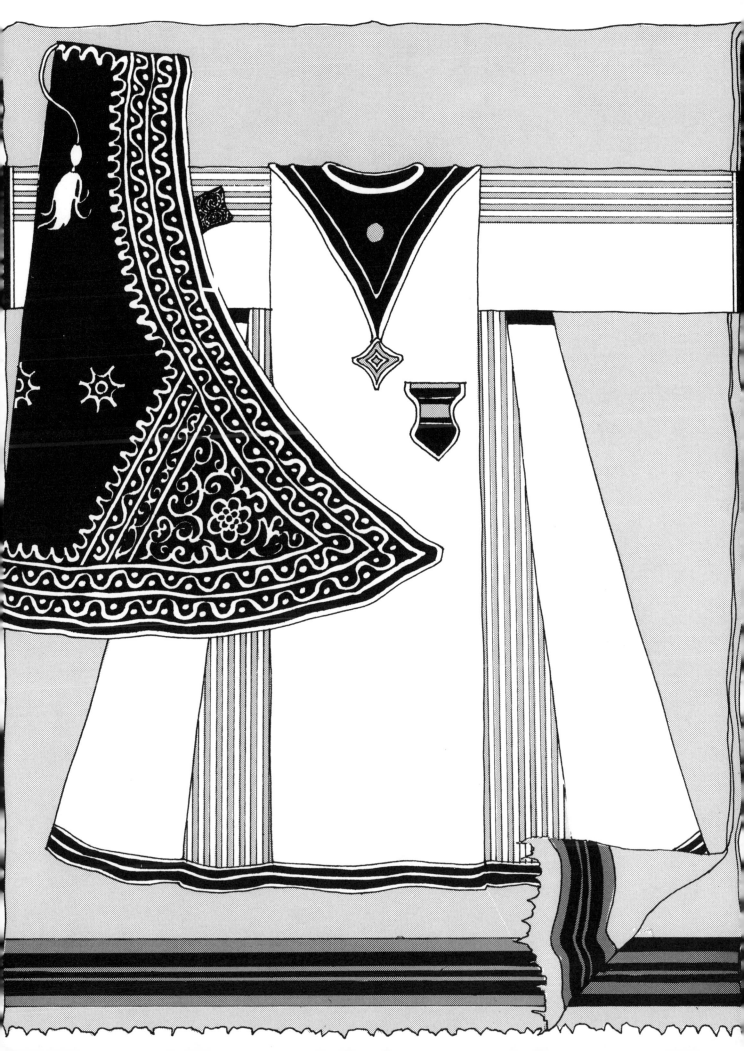

The Sahara

The desert-dwellers of the Sahara include the Berber Tuaregs and the legendary Moors of the central mountains and areas along the Niger. The Tuareg are largely of traditional African and Berber descent, whereas the Moors are bedouins of mixed Berber and Arab origin. Of the Sahara's traditional inhabitants, some sixty per cent farm in the oases, both natural ones and those irrigated by water pumped from great depths. The rest rely on the herding of goats, camels and sheep.

The designs of the Tuaregs and the Moors reflect the way in which their lives have evolved. The Tuaregs maintain their Berber characteristics of bold and simple designs, while the Moors incorporate the lifestyles and patterns of the local African people from western Savannah, and particularly the flamboyant designs of the Arabs.

The Tuaregs adopted Islam but retained many of their Berber ways. Tuareg women go unveiled and both groups of people once divided their societies into strict hierarchies of nobles, vassals and religious men, all distinguished by clothing designs. In modern times, however, the designs of the attire usually indicate regional differences rather than class distinction. However, colors and patterns still play an important role in each nomadic society. For the Tuareg, certain colors have specific virtues. Blue represents the purity of the sky, white represents the health of the servant, and violet stands for the dove, a symbol of love and gentleness.

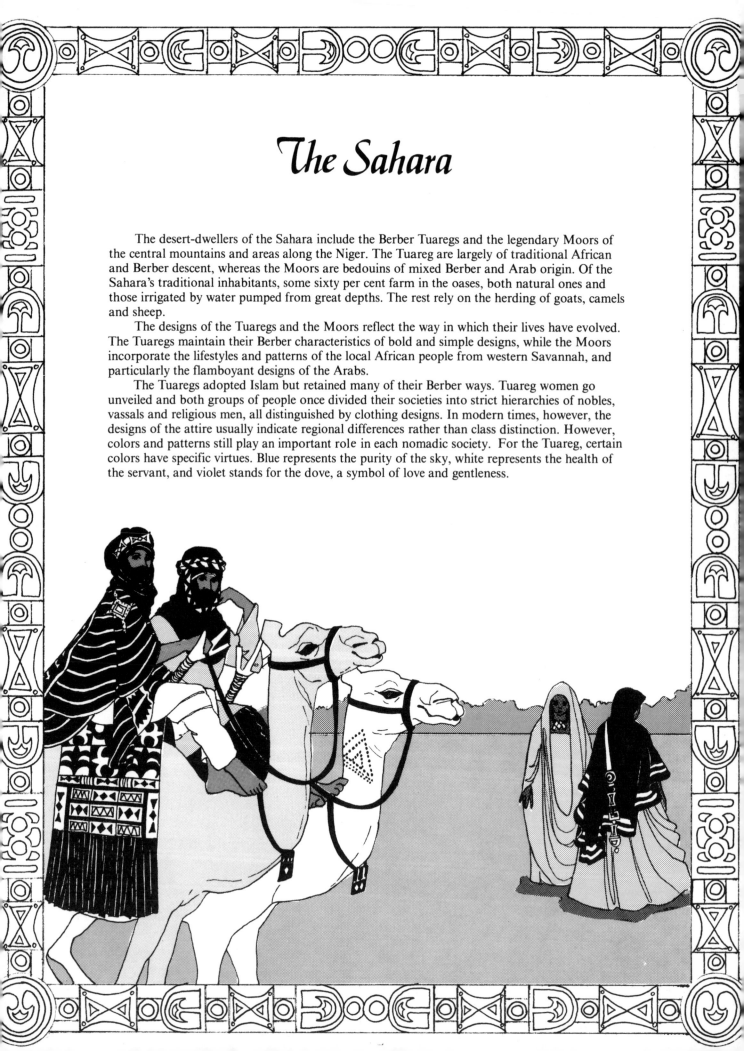

Silver cases containing suras (chapters) from the Quran are worn around the necks of both Tuareg and Moorish men. The Quran cases are highly valued as protective devices.

Traditional Tuareg designs are clean-cut and geometric, adhering to a few basic motifs which are repeated time after time in embroidery and leatherwork patterns. This is a result of the proud austerity of their existence in a hostile environment which lacks visual inspiration. They are extremely formal in habit and dress, having accepted the doctrines of Islam and the conformity imposed by desert life. Class distinction is indicated by the tagelmoust worn by the men. The tagelmoust is a twenty-foot-long cloth turban. The way it is worn indicates a man's status within his group. It also serves the practical purpose of protecting the Tuareg from blistering heat and brutal sandstorms. Some men of nobility wear brass, copper or silver tcherot amulets attached to the tagelmoust.

Wealthy men wear tagelmoust of a deep indigo diaphanous cloth with a lustrous sheen. The shimmering cloth is a result of pounding the expensive dye into the fabric instead of soaking, because of the lack of precious water in the desert. This technique causes the indigo to penetrate the skin of the Tuareg, the reason they are referred to as "the Blue Men of the Desert." In most regions, Tuareg women uniformly dress in black or blue indigo. However, women of other regions across the Sahara wear traditional African clothing designed and made by bordering coastal craftsmen of the Sahel. Their jewelry is made mostly of silver, the metal of the Prophet. Some bedouins do not wear gold, because it is believed to bring bad luck by giving way to fortune and greed. At the age of 17, the Niger Tuareg girls receive from their mothers a silver tcherot and a khomissar made of shell as a symbol of passage into womanhood. Other Tuareg women, however, wear crosses referred to as "golden-winged pendants," which represent the four corners of the world and are believed to be powerful talismans. The designs on the crosses are highly stylized symbols of fertility, and have been popular in Africa for 4,000 years.

The Moorish women also wear robes of blue indigo and black, and the jewelry designs are very similar to those of the Tuareg, but with a distinct Arab flair. They wear small talismans containing suras, and brightly colored glass and carnelian beads adorn the necks, hands, heads, hair, arms and ankles of Moorish women.

During a ceremonial dance called the "Guedra," Moorish women drape themselves in black veils which draw attention to the exquisite tattoos painted on their hands and feet. The tattoo designs, applied with henna, are of a protective significance. The graceful dance movements seem even more so because they are accentuated by their elaborate hair designs. Every plait of their long flowing corn rolls is threaded with a variety of beads such as multicolored Venetian glass beads, millefiori, amber, carnelian, shell, ebony, gazelle horn, silver and gold pendants. Moorish women are truly a sight to behold!

The illustrations in this section show some of the differences between the flamboyant creations of the Moors and the simpler designs of the noble Tuaregs.

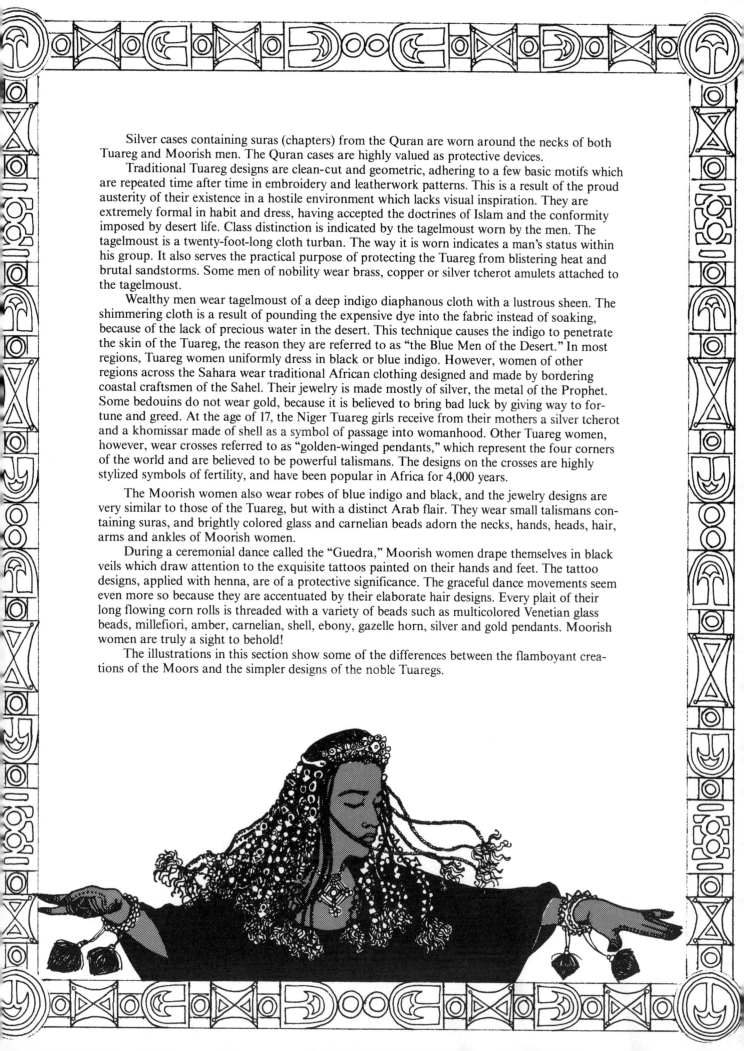

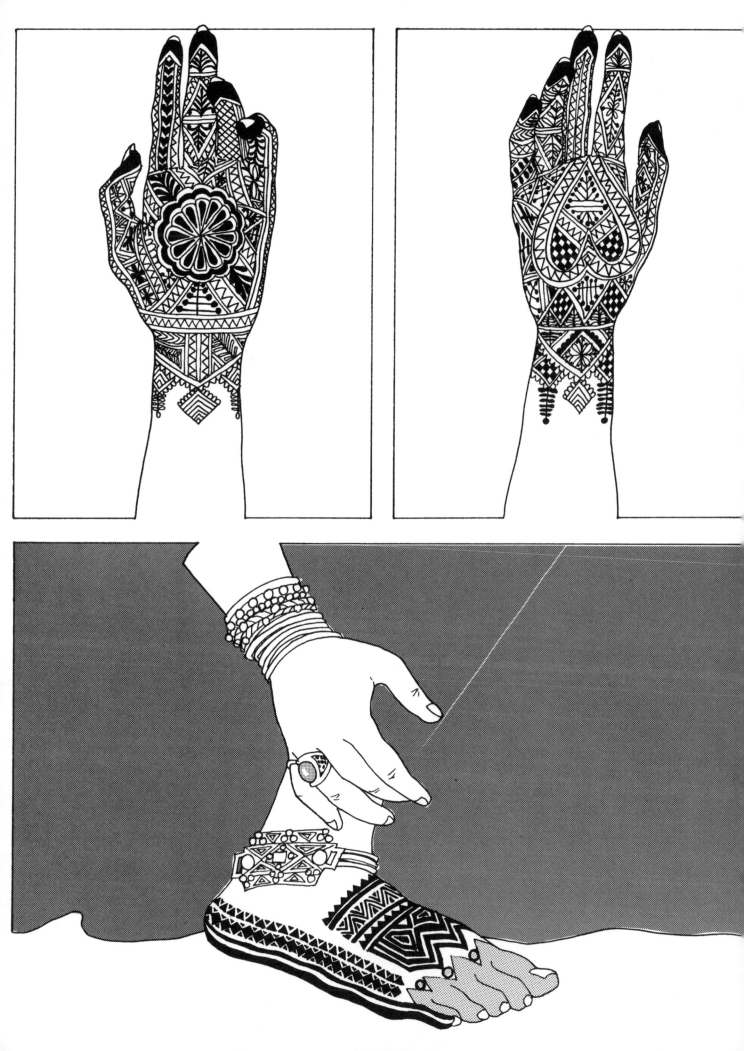

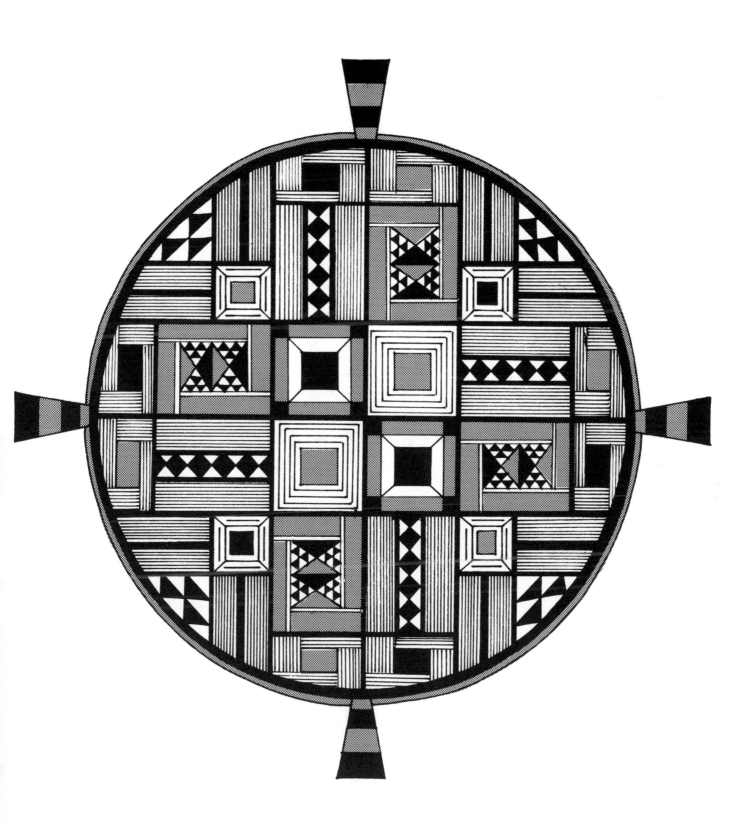

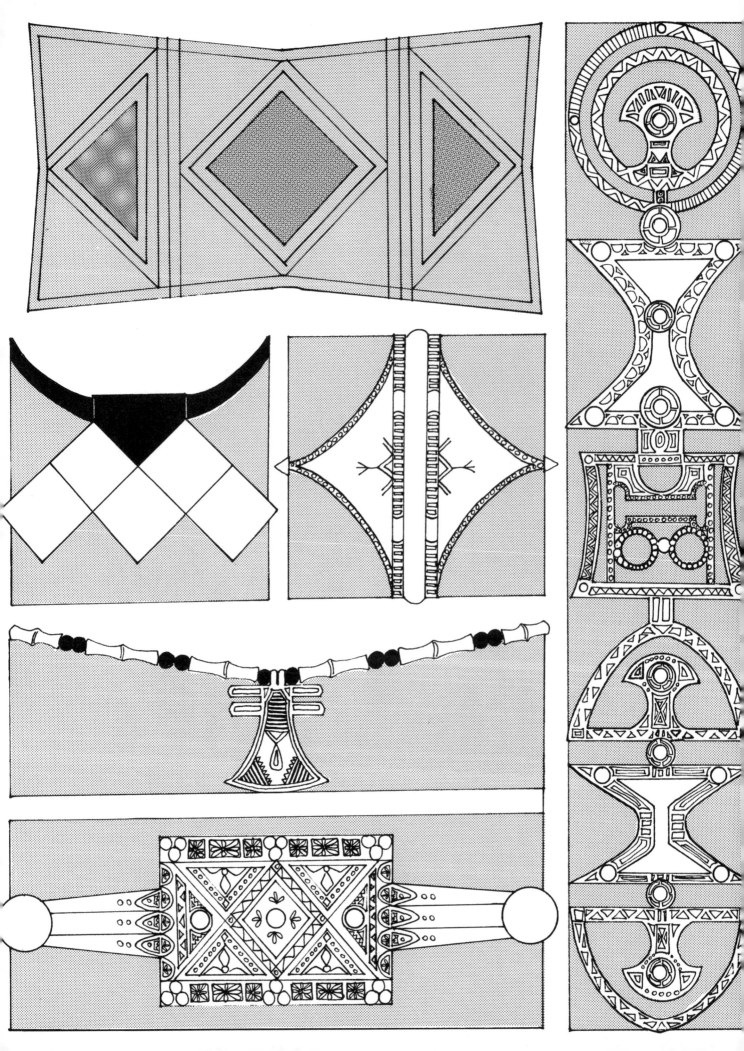

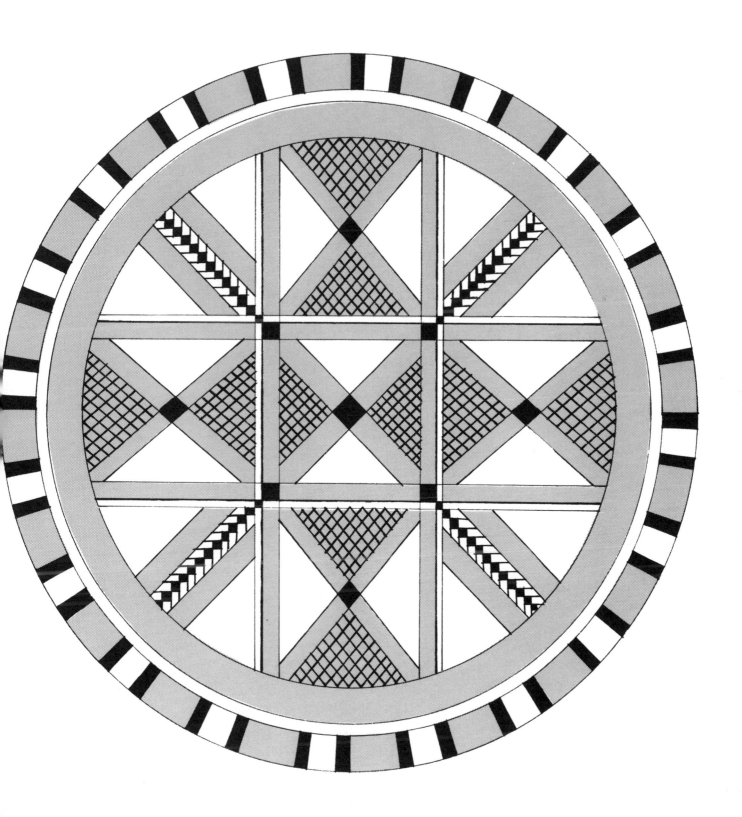

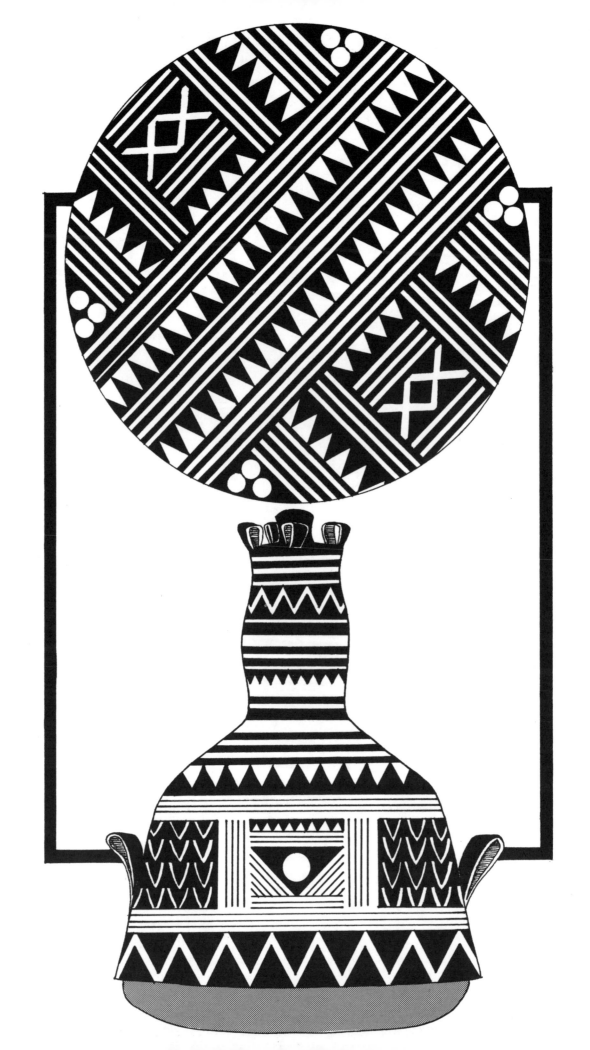

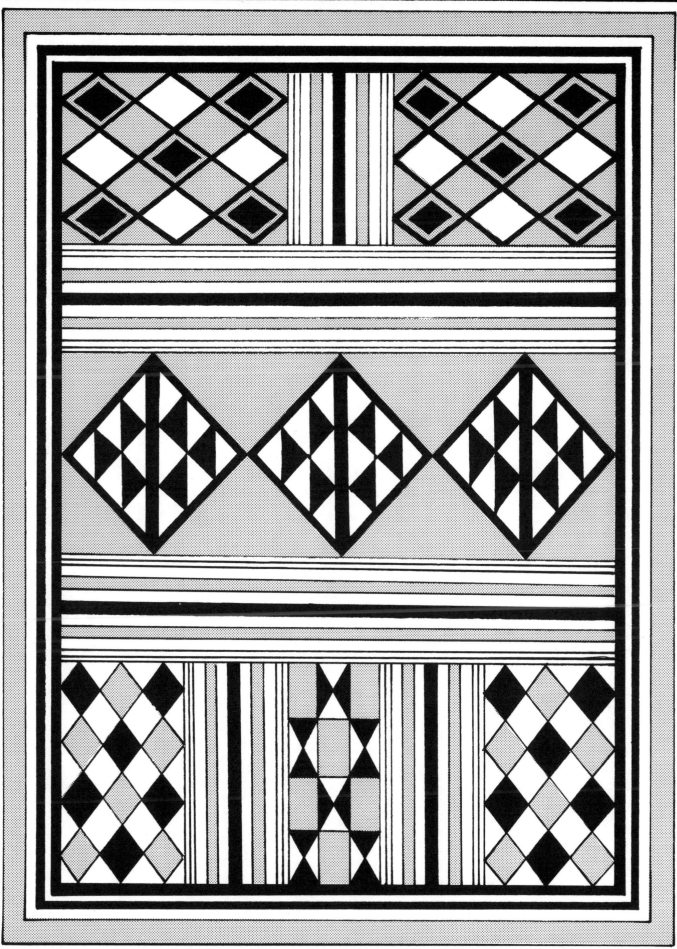

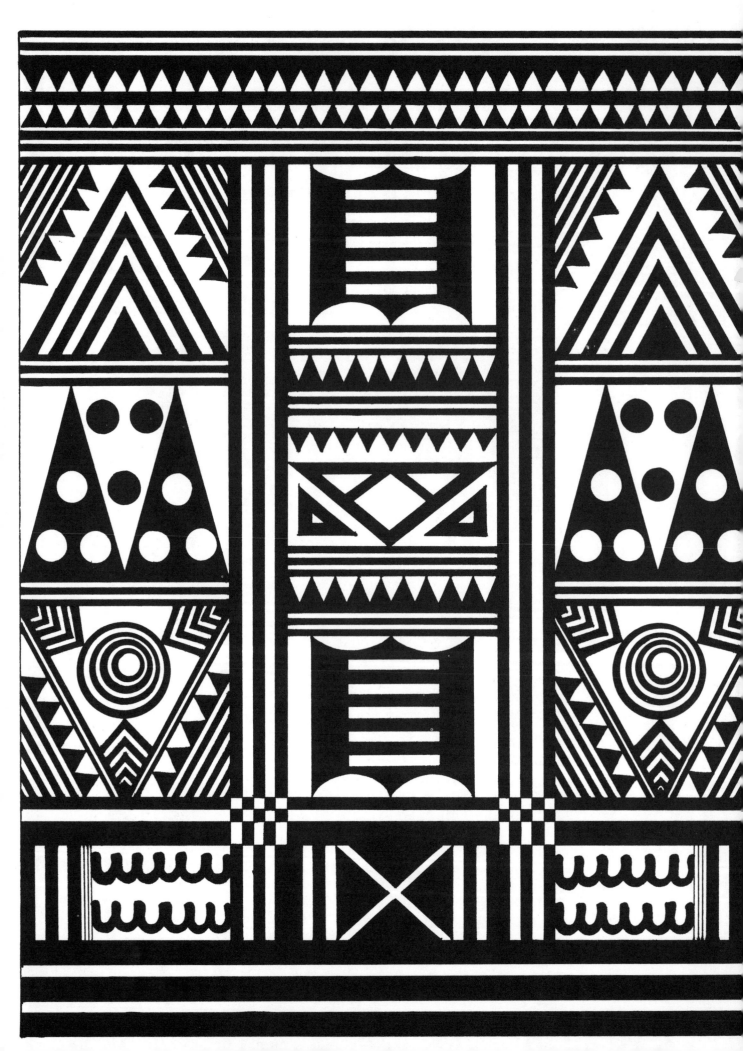

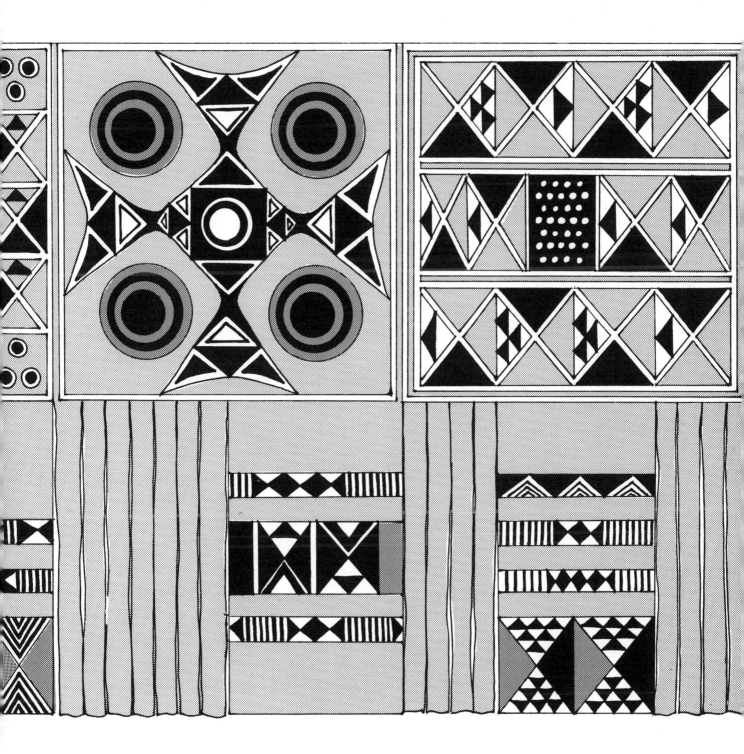

The Savannah

Between the forest in the south and the Sahara in the north, the scanty Savannah is peopled by cattle-herding Fulani of Hamitic and African descent. The nomads travel from the neck of Mali, above Timbuktu, across West Africa to southwest Chad.

The Savannah links important trade routes from West to North Africa, and there is a constant flow of goods between traveling merchants and local people. The most important African Centers for Islamic learning and trade are located in the sister cities of Djenne and Timbuktu along the Niger River, bordering the Sahara and the Savannah. Since the fifteenth century, this region has been the home of the Fulani.

Traditional Fulani have resisted outside cultural influences. Many take pride in referring to themselves as the "Wodaabe," meaning people of the taboo. They adhere to the traditions characterized by poise and reserve. Though they have adopted Islam, they usually use Muslim prayers and rituals to supplement their own practices. However, their designs have been influenced by the Moors and Tuaregs with whom Fulani come in contact along the trade routes.

The men wear turbans under large straw hats decorated with dyed leather appliques. Under a flowing robe called a "bou-bou," they wear a simple light colored sheer tunic and darker colored light weight trousers. Fulani women often embroider men's tunics with geometric designs. The men decorate their camels with multicolored leather saddles, leather amulets and brightly colored wool saddle blankets. Most objects of leather are items of personal adornment, dress and regalia. However, there are only a few objects of leatherwork that can be definitely attributed with any certainty to a particular nomadic group. Perhaps the most important factor in this is the mobility of the bedouins, brought into contact with people of diverse ethnic and cultural backgrounds and consequently exchanging objects and ideas.

Wodaabe women also embroider their own blouses and skirts, and make jewelry from small coins, pendants, cowrie shells and glass beads. They also tattoo their faces with traditional designs that offer protection against the evil eye. Brightly colored and highly decorative headscarves are worn as objects of glamour and prestige and to conform to the code of Islam. Fulani women take pride in their collections of ceremonial calabashes, which are given to girls when they marry.

Most of the Fulani designs are made by Bella and Hausa craftsmen living along the trade routes. Jewelry designs are produced by the craftsmen under specific requirements of the Fulani nomads. Some of the jewelry designs incorporate simple geometric shapes cut out of brass and copper plaques and are worn by men on their turbans. During festivities, the Fulani add beautiful accessories such as mirrors, gemstones, pendants and amulets to enhance their already uniquely designed attire.

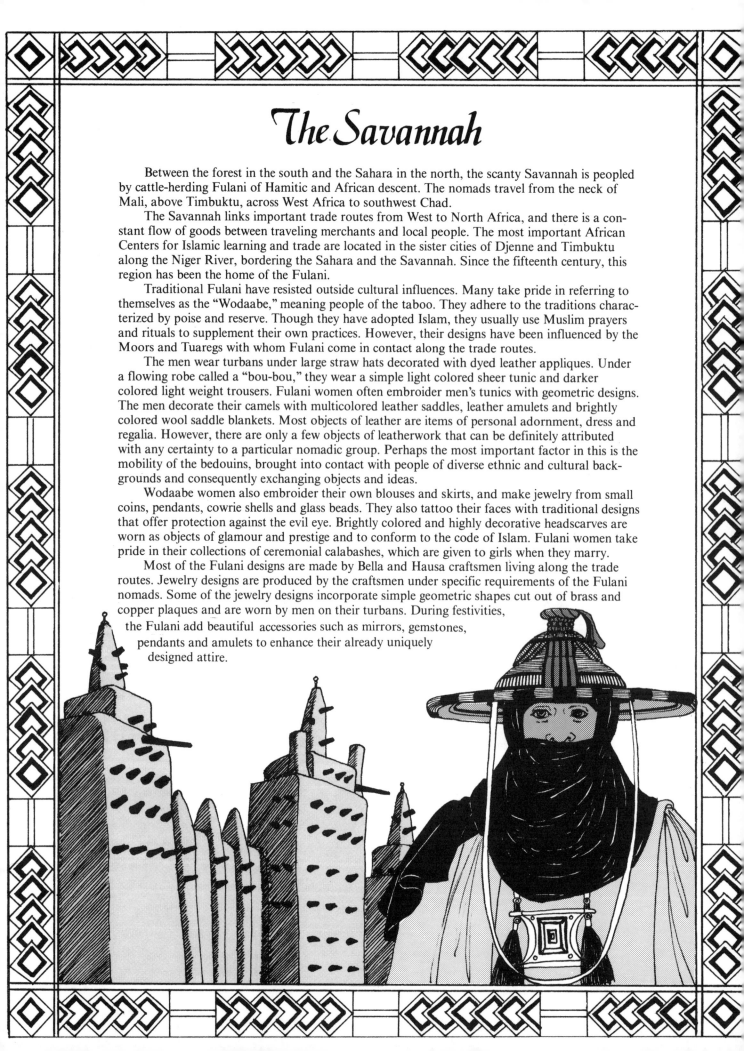

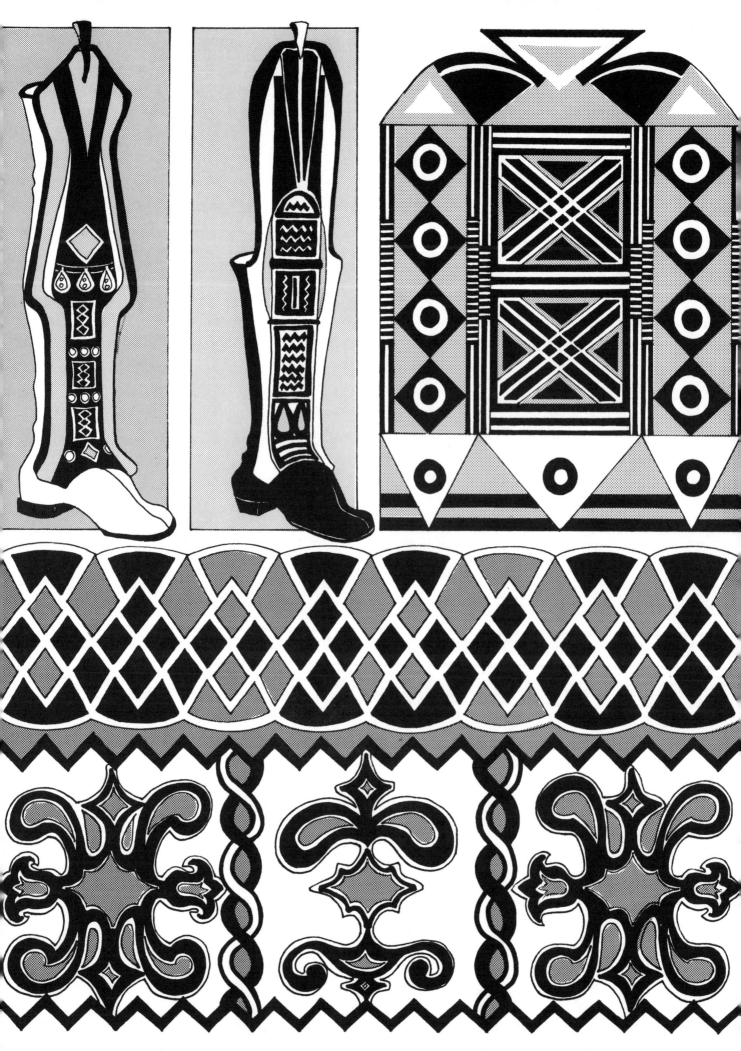

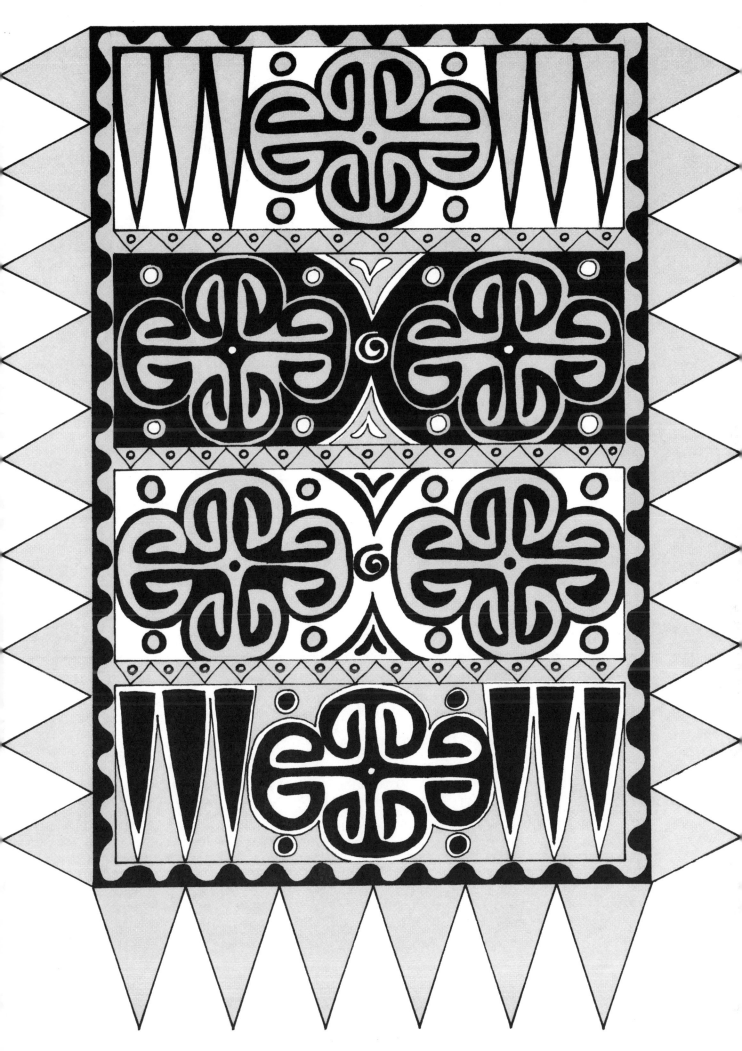

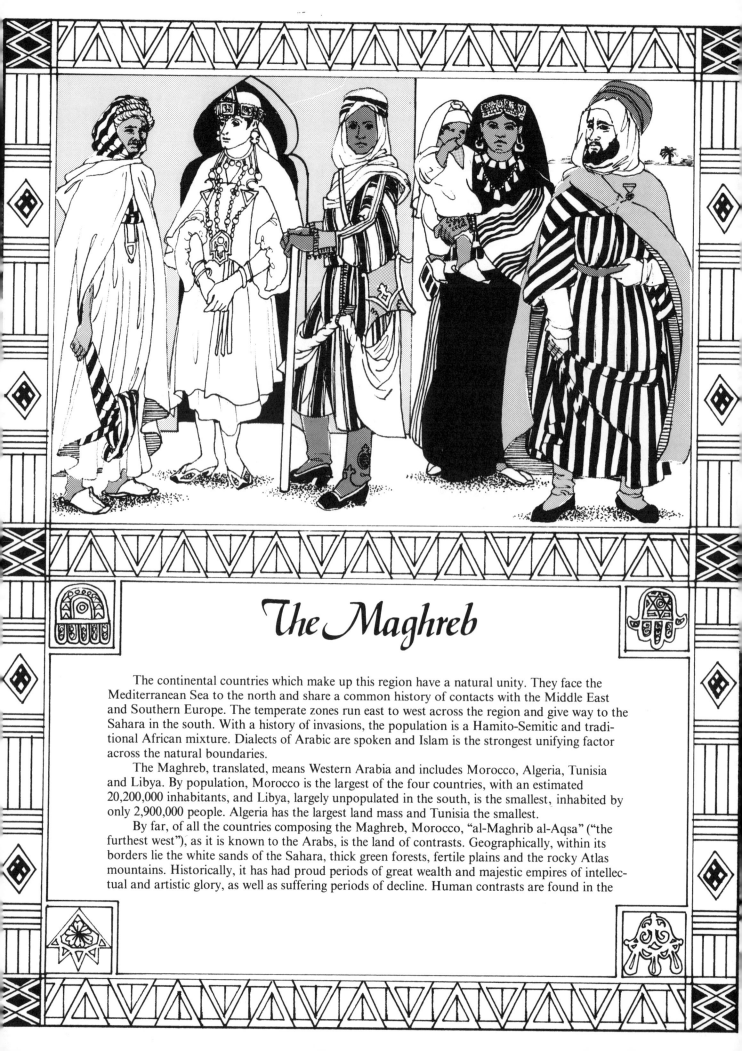

The Maghreb

The continental countries which make up this region have a natural unity. They face the Mediterranean Sea to the north and share a common history of contacts with the Middle East and Southern Europe. The temperate zones run east to west across the region and give way to the Sahara in the south. With a history of invasions, the population is a Hamito-Semitic and traditional African mixture. Dialects of Arabic are spoken and Islam is the strongest unifying factor across the natural boundaries.

The Maghreb, translated, means Western Arabia and includes Morocco, Algeria, Tunisia and Libya. By population, Morocco is the largest of the four countries, with an estimated 20,200,000 inhabitants, and Libya, largely unpopulated in the south, is the smallest, inhabited by only 2,900,000 people. Algeria has the largest land mass and Tunisia the smallest.

By far, of all the countries composing the Maghreb, Morocco, "al-Maghrib al-Aqsa" ("the furthest west"), as it is known to the Arabs, is the land of contrasts. Geographically, within its borders lie the white sands of the Sahara, thick green forests, fertile plains and the rocky Atlas mountains. Historically, it has had proud periods of great wealth and majestic empires of intellectual and artistic glory, as well as suffering periods of decline. Human contrasts are found in the

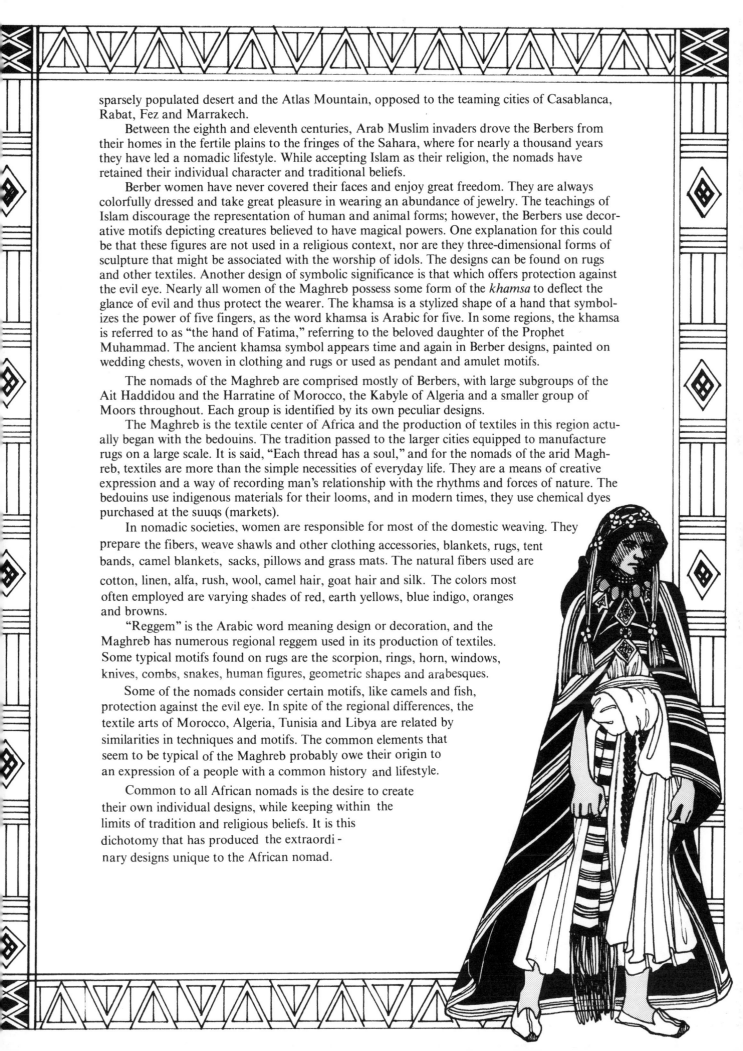

sparsely populated desert and the Atlas Mountain, opposed to the teaming cities of Casablanca, Rabat, Fez and Marrakech.

Between the eighth and eleventh centuries, Arab Muslim invaders drove the Berbers from their homes in the fertile plains to the fringes of the Sahara, where for nearly a thousand years they have led a nomadic lifestyle. While accepting Islam as their religion, the nomads have retained their individual character and traditional beliefs.

Berber women have never covered their faces and enjoy great freedom. They are always colorfully dressed and take great pleasure in wearing an abundance of jewelry. The teachings of Islam discourage the representation of human and animal forms; however, the Berbers use decorative motifs depicting creatures believed to have magical powers. One explanation for this could be that these figures are not used in a religious context, nor are they three-dimensional forms of sculpture that might be associated with the worship of idols. The designs can be found on rugs and other textiles. Another design of symbolic significance is that which offers protection against the evil eye. Nearly all women of the Maghreb possess some form of the *khamsa* to deflect the glance of evil and thus protect the wearer. The khamsa is a stylized shape of a hand that symbolizes the power of five fingers, as the word khamsa is Arabic for five. In some regions, the khamsa is referred to as "the hand of Fatima," referring to the beloved daughter of the Prophet Muhammad. The ancient khamsa symbol appears time and again in Berber designs, painted on wedding chests, woven in clothing and rugs or used as pendant and amulet motifs.

The nomads of the Maghreb are comprised mostly of Berbers, with large subgroups of the Ait Haddidou and the Harratine of Morocco, the Kabyle of Algeria and a smaller group of Moors throughout. Each group is identified by its own peculiar designs.

The Maghreb is the textile center of Africa and the production of textiles in this region actually began with the bedouins. The tradition passed to the larger cities equipped to manufacture rugs on a large scale. It is said, "Each thread has a soul," and for the nomads of the arid Maghreb, textiles are more than the simple necessities of everyday life. They are a means of creative expression and a way of recording man's relationship with the rhythms and forces of nature. The bedouins use indigenous materials for their looms, and in modern times, they use chemical dyes purchased at the suuqs (markets).

In nomadic societies, women are responsible for most of the domestic weaving. They prepare the fibers, weave shawls and other clothing accessories, blankets, rugs, tent bands, camel blankets, sacks, pillows and grass mats. The natural fibers used are cotton, linen, alfa, rush, wool, camel hair, goat hair and silk. The colors most often employed are varying shades of red, earth yellows, blue indigo, oranges and browns.

"Reggem" is the Arabic word meaning design or decoration, and the Maghreb has numerous regional reggem used in its production of textiles. Some typical motifs found on rugs are the scorpion, rings, horn, windows, knives, combs, snakes, human figures, geometric shapes and arabesques.

Some of the nomads consider certain motifs, like camels and fish, protection against the evil eye. In spite of the regional differences, the textile arts of Morocco, Algeria, Tunisia and Libya are related by similarities in techniques and motifs. The common elements that seem to be typical of the Maghreb probably owe their origin to an expression of a people with a common history and lifestyle.

Common to all African nomads is the desire to create their own individual designs, while keeping within the limits of tradition and religious beliefs. It is this dichotomy that has produced the extraordinary designs unique to the African nomad.

Jewels of Morocco

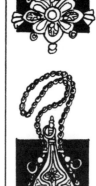

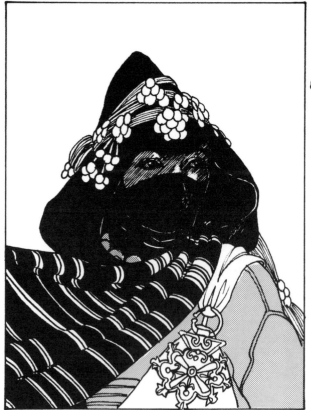

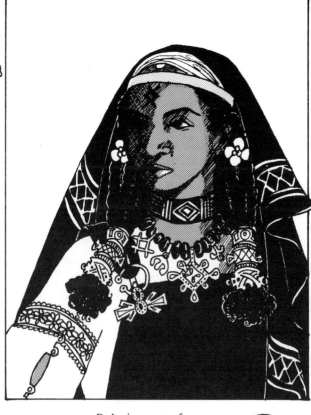

Berber woman from
Ait Hadiddou group
wearing a silver
jackal's paw pin,
symbol of fertility.

Bedouin woman from
the Draa Valley wearing
a Khourb triangular
talisman.

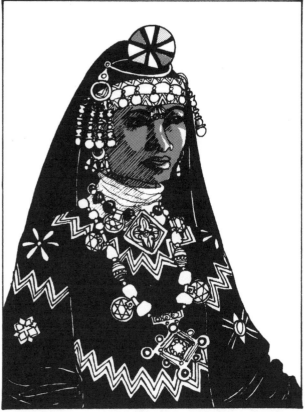

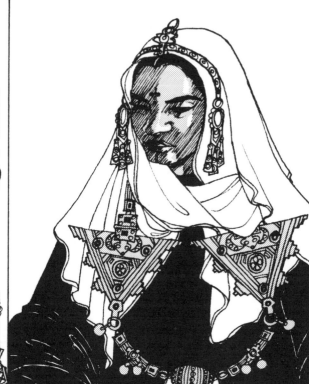

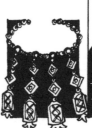

Haratine woman wearing
a Besakou pendant
containing verses from
the Quran.

Tiznit bedouin
of the Atlas Mountains
wearing a fibula clasp,
an indication of status.

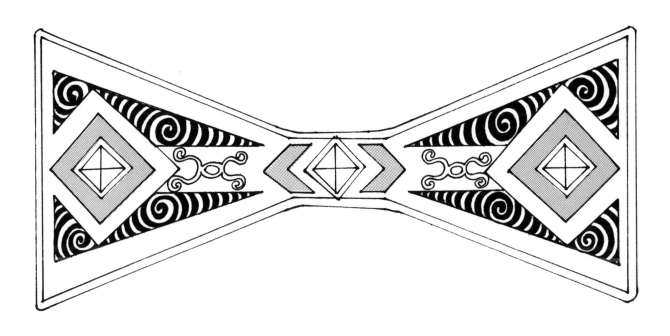

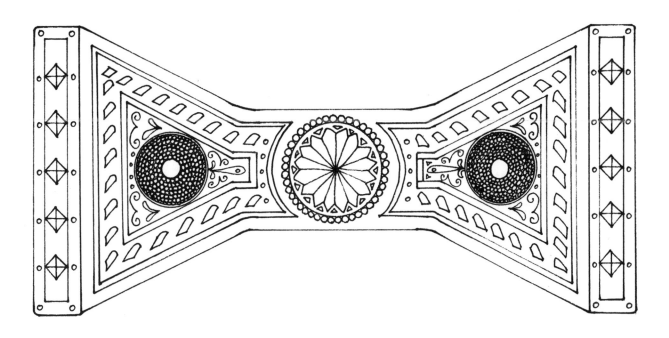

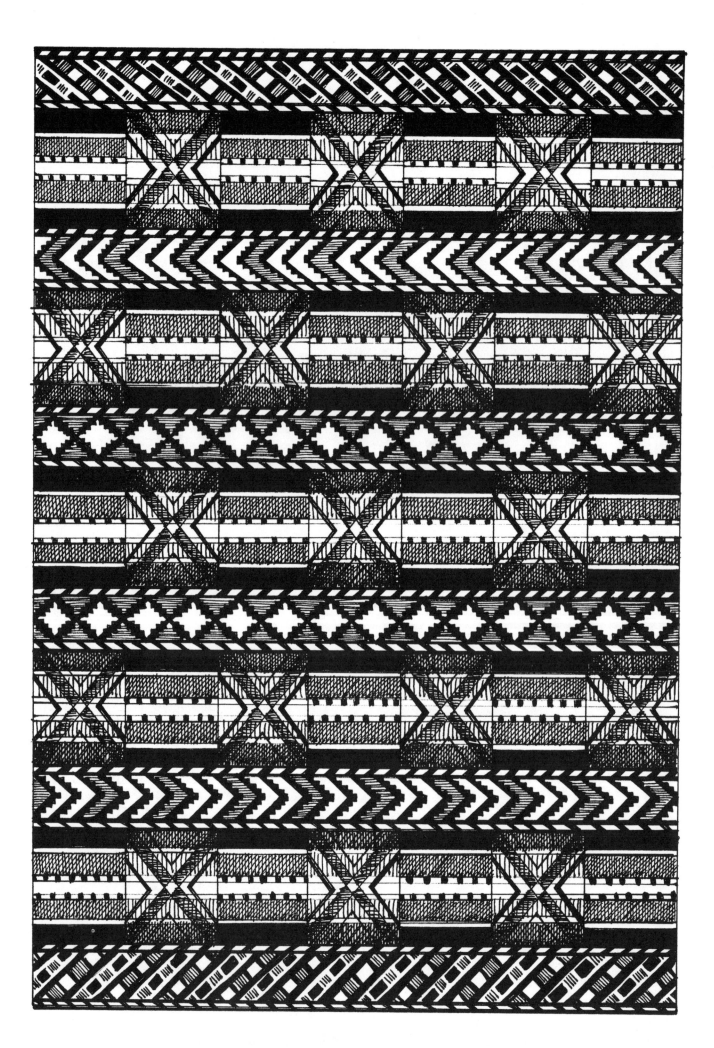

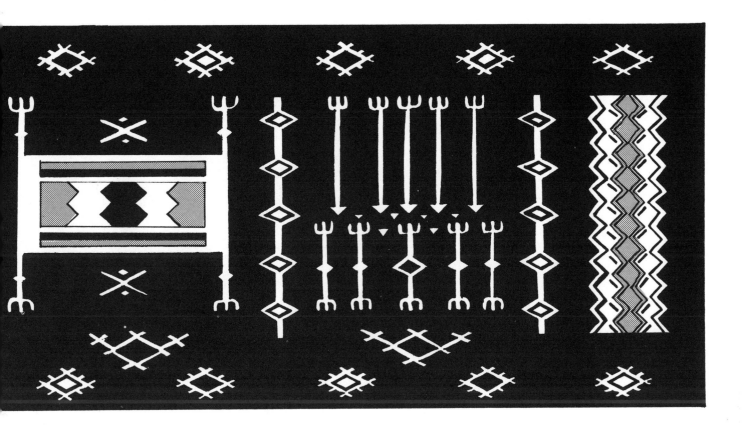

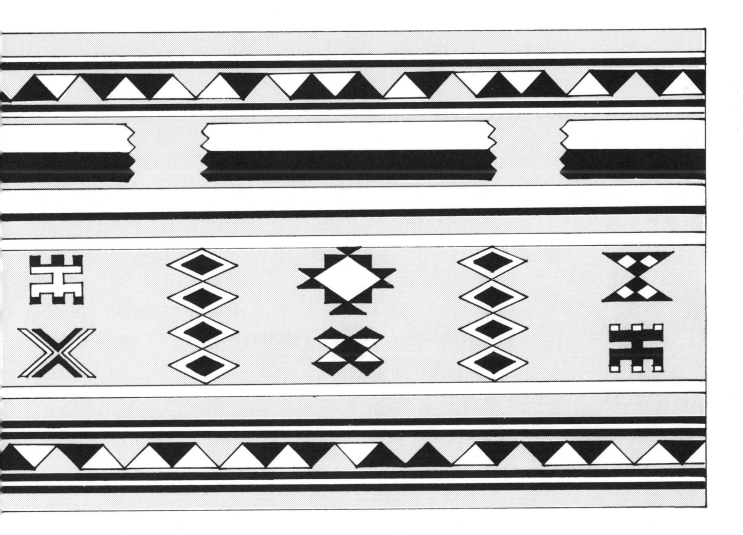

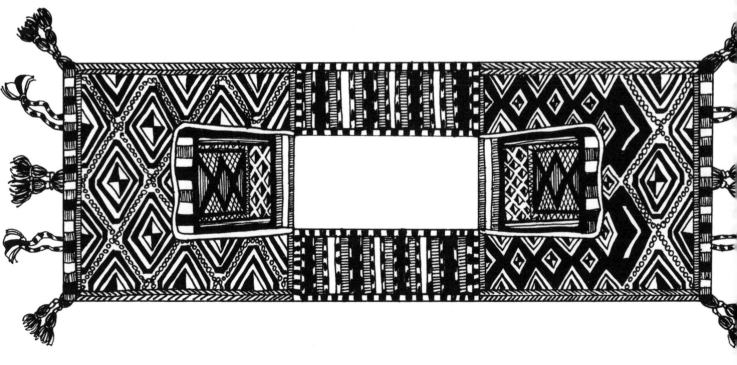

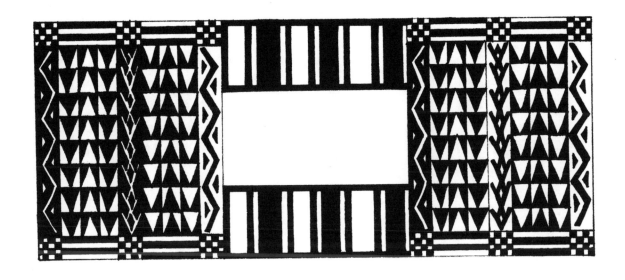

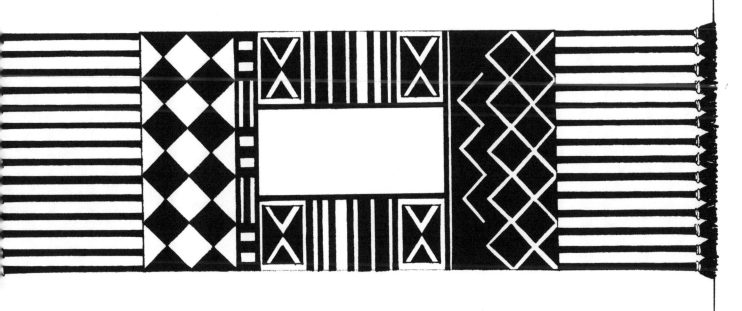

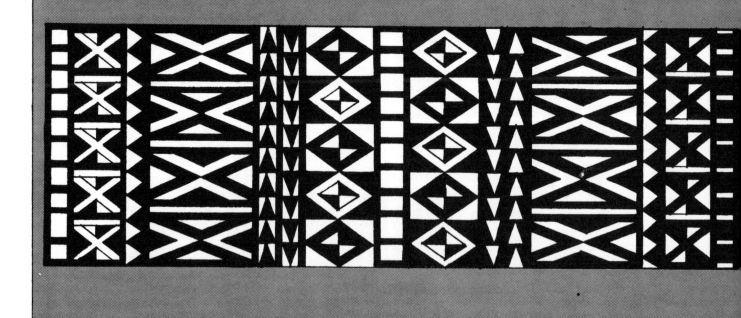

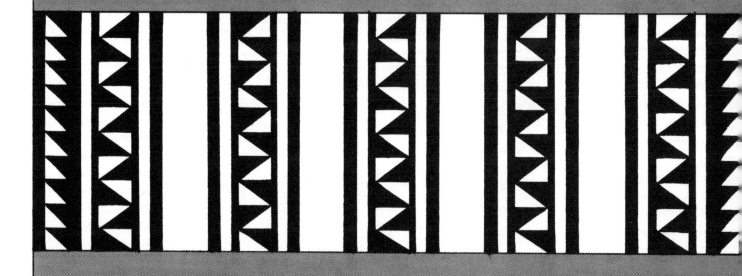

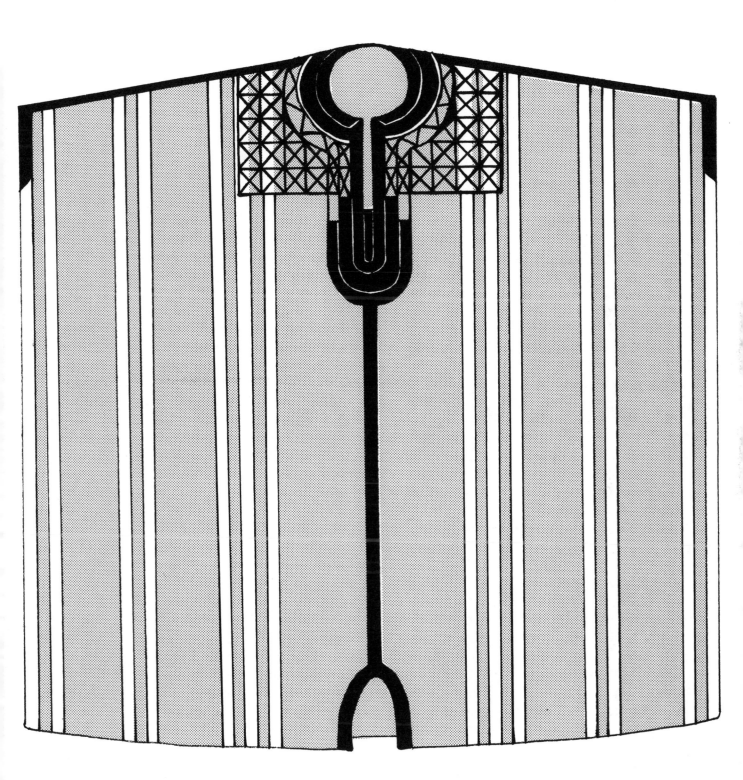

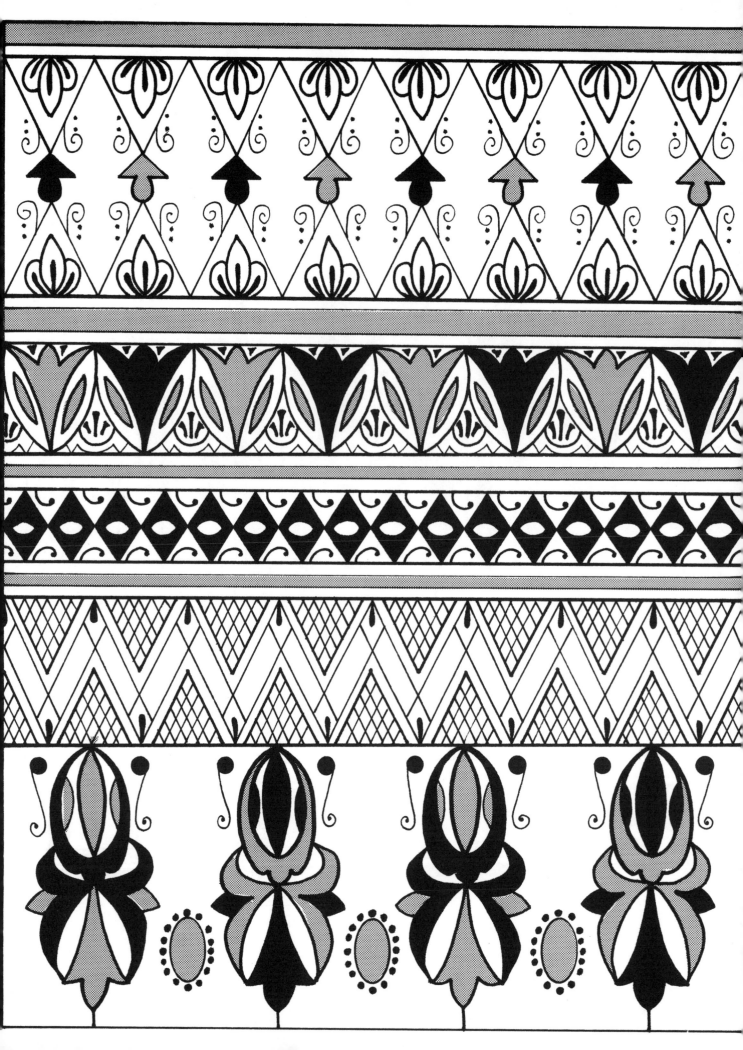

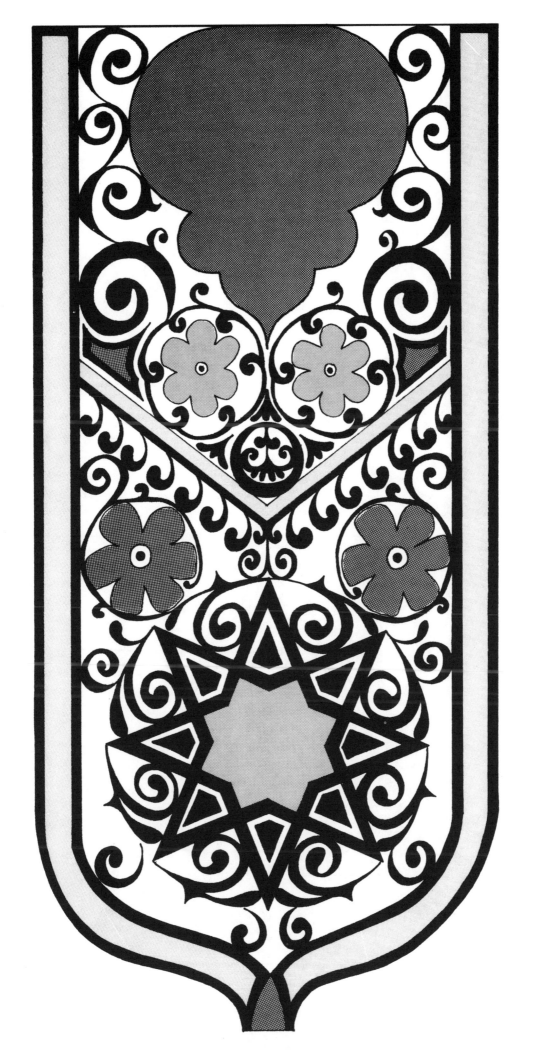

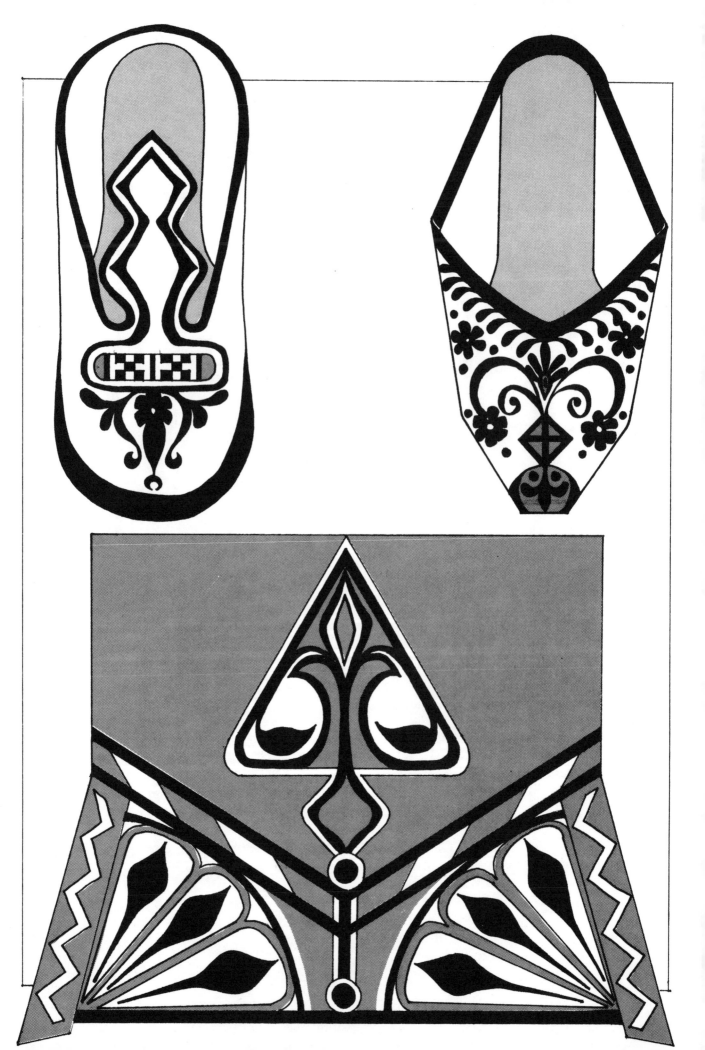

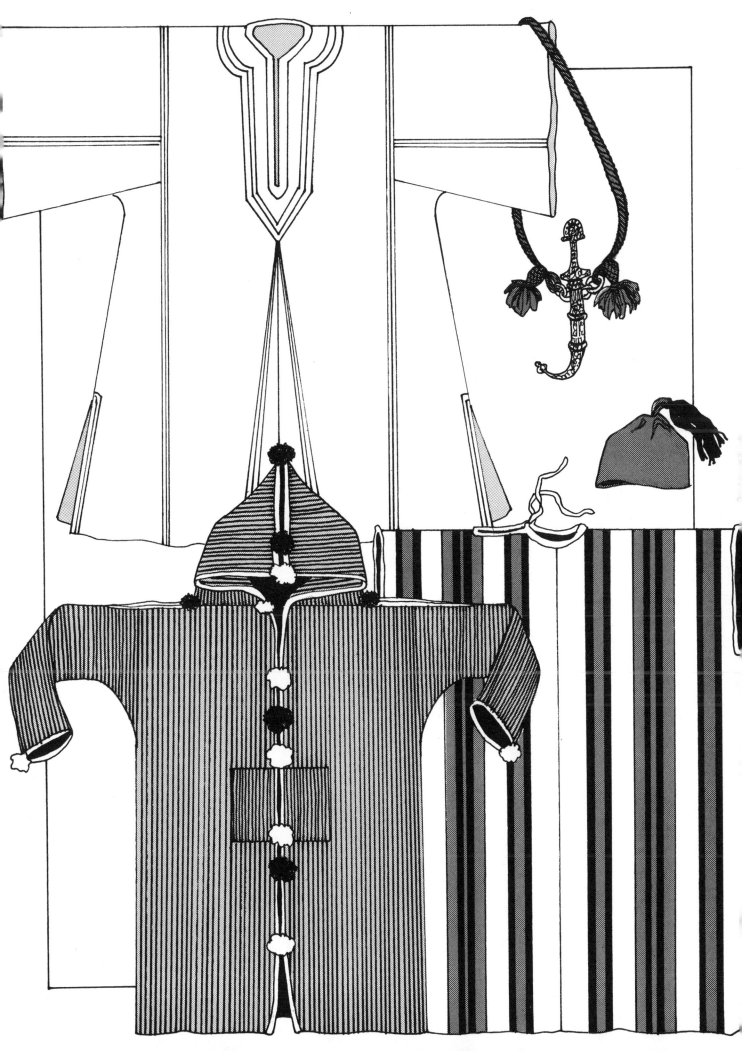

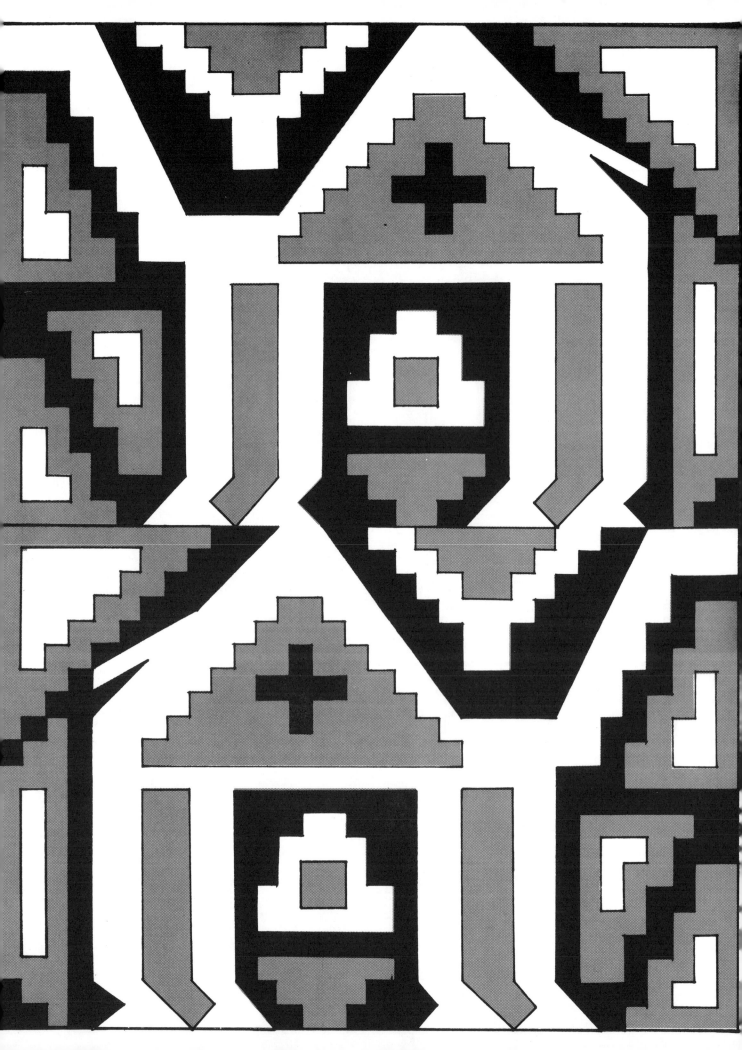

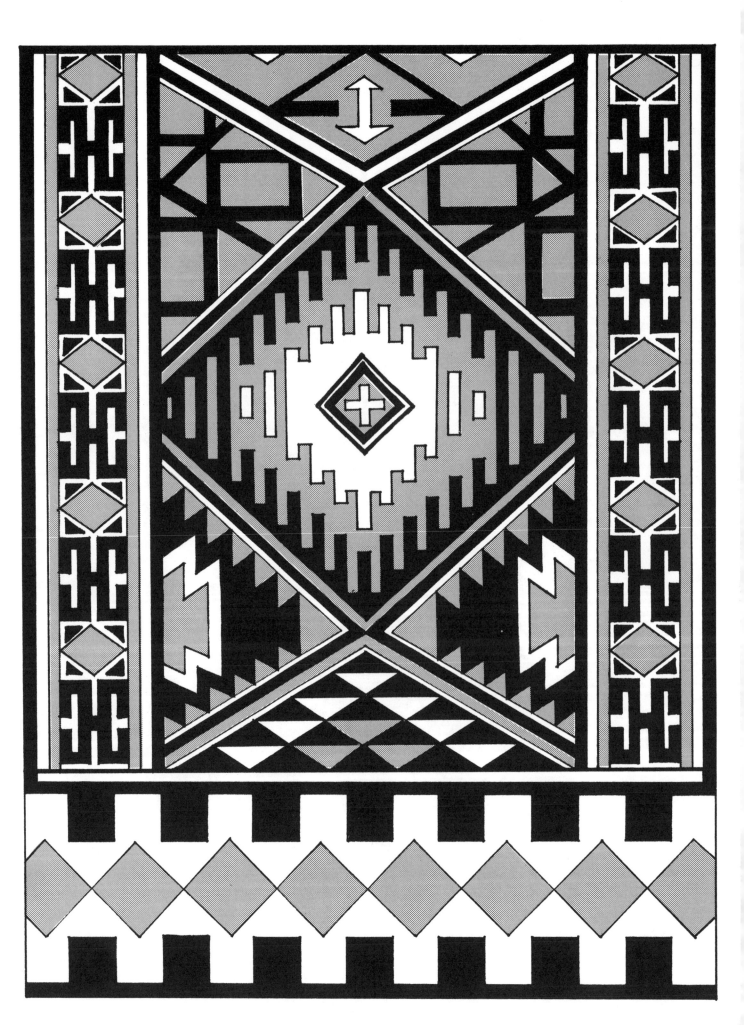

Glossary

ABYSSINIAN	An inhabitant of Ethiopia
ARABESQUE	An elaborate design of intertwined vines, suggesting foliage
BERBER	A member of one of several Muslim groups of North Africa and a branch of the Afro-Asiatic language
BABOUCHES	Tooled-leather pointed slippers worn by Moors
BURNOOSE, BURNOUS	Long hooded black or white cloak worn by the Moors
CALABASH	Large hard-shelled gourd
CARAVAN	A company of travelers journeying together, especially across a desert
COPT	A native of Egypt
COPTIC	The Afro-Asiatic language used today in the liturgy of the Coptic Church
DJENNE	Border city and trade center in Central Mali
EVIL EYE	Feared throughout the Mediterannean world; a power held by certain people whose stares or glances are thought to bring misfortune
FULANI	A member of Muslim people of the Savannah of African and Hamitic descent
GUEDRA	Festival and dance performed by Moorish women
HAIK	A five-yard-long woolen cloth, draped and worn by men of the Maghreb
JELLABA (DJELLABA)	A long, often striped, loose woollen garment with a hood, worn over a sleeveless shirt, or jebba, by men in North Africa
KIBR	Long brown-and-white striped cotton shirt worn by men of the Maghreb
MAGHREB	Arabic for Western Region of northwestern Africa consisting of the Atlas mountains, Algeria, Morocco, Tunisia and Libya
MOOR	A member of a Muslim people of mixed Berber and Arab descent living in North Africa
SAHEL	Semidesert and dry grassland region fringing the Sahara in the south
SHAMA	Ethiopian and Sudanese men's tunic
SKARRA	Silk embroidered leather bag with woollen cord worn over the shoulder of North African men
TIMBUKTU	City in central Mali, near the Niger river, founded in the 11th century. Trading center, especially for gold, and a leading intellectual center of Islam
TUAREG	Member of nomadic group occupying western and central Sahara and along the Niger, who have adopted Islam
WASM	Arabic word for "mark"
YASHMAK (YASHMAQ)	Veils worn since ancient times, possibly developed originally to protect the face from sun and sand. Muslim customs later decreed that they should be worn by women in public as a gesture of modesty

Bibliography

African-American Institute. *Beauty by Design: The Aesthetics of African Adornment,* catalogue. New York, 1985

BOSSERT, H. TH. *Ornament in Applied Art.* New York: E. Weyhe, 1924

BRUHN, WOLFGANG and TILKE, MAX. *Pictorial History of Costume.* New York: Arch Cape Press, 1988

Cultural Atlas of Africa. New York: Facts on File, Inc., 1981

FISHER, ANGELA. *Africa Adorned.* New York: Abrams, 1984

KRIGER, COLLEEN. *Robes of the Sokoto Caliphate.* African Arts, Vol. 21, No. 3 (1988), pp. 52-57

MASS, PIERRE. *Djene: Living Tradition.* ARAMCO World, Vol. 41, No. 6 (1990), pp. 19-29

Museum of Contemporary Art. *Contemporary African Fabrics,* catalogue. Chicago, 1975

RACINET, M.A. *Le Costume Historique.* Paris: Firman Didot et C, n.d.

RESWICK, IRMTRAUD. *Traditional Textiles of Tunisia and Related North African Weaving.* Los Angeles: Crafts and Folk Art Museum, 1985

REVAULT, JACQUES. *Designs and Patterns from North African Carpets and Textiles.* New York: Dover, 1973

STONE, CAROLINE. "Embroidery from North Africa." ARAMCO World, Vol. 3, No. 6 (1987), pp. 12-19

Tapis du Haut Atlas et du Haouz de Marrakech. *Corpus des Tapis Marocains.* Paris: Librairie Orientaliste Paul Geuthner, 1927

Textile Museum. *De L'extreme Occident: Tapis et Textiles du Maroc.* Morocco, 1980

TILKE, MAX. *National Costumes from East Europe, Africa and Asia.* New York: Hastings House Publishers, Inc. 1978

Designed by Barbara Holdridge
Composed in Times Roman by Brown Composition, Baltimore, Maryland
Cover color-separated by Graph Tec, Baltimore, Maryland
Printed on 75-pound Williamsburg Offset paper and bound by Bookcrafters, Inc., Fredericksburg, Virginia

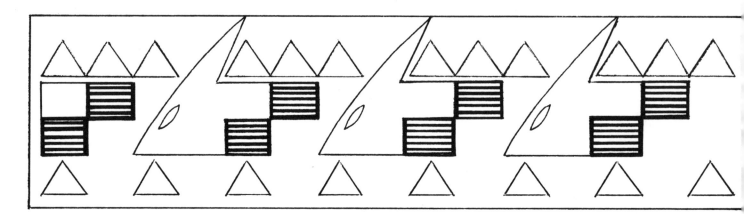